Daylight

Dirty Birdy Bible

Hiro Tanaka

田中 ヒロ

Cofounders: Taj Forer and Michael Itkoff
Editorial Assistant: Nicholas Locke

© 2019 Daylight Community Arts Foundation

Illustrations © 2019 by Hiro Tanaka
Forword© 2019 Jeff Rosenstock

ISBN: 978-1-942084-61-7

Printed by Ofset Yapımevi, Turkey

Daylight Books
E-mail: info@daylightbooks.org
Web: www.daylightbooks.org

FOREWORD

Hiro Tanaka's famed notebooks contain a depraved
journey through the English language, viewed through
the lens of touring musicians who regularly talk about
shitting, fucking, masturbating, fast food and the
results thereof, getting fucked up and the darkness
that engulfs all life. Conversations in the van are often
conversations that couldn't possibly live outside of
the van for the world would be mortified to hear the
grotesque responses to hypothetical questions, spoken
in a language that is both coded and profane. It is the
underbelly of truth, unacceptable expressions suited
only for the handful of people spending hours upon
hours staring out the window of a small moving tube.

Looking through these pages now feels like revisiting
the hours and hours of boredom in the van, the
adrenaline/substance cocktail of an after-show party,
and the late-night/early-morning quest for epiphanies,
hunting via deep conversations with people who know
how truly fucked up you are. This book is a document,
a kaleidoscopic scramble of unfiltered and mostly
inappropriate thoughts, capturing the hidden id of a
country in a downward spiral. It is completely insane
and terrifying.

-Jeff Rosenstock

ounding expanding the
 size of the penis hole

DOCKING

~~RODING~~ — IS THE ABILITY TO
STICK YOUR PENIS IN ANOTHER
MANS ~~URETHRA~~ DICK HOLE AFTER
SOUNDING.

boob catalog — one's mental
 collection of naked breasts
 that have been seen.

whackadex — mental roladex
 of images to masturbate
 ("whack") to.

whnk-shnk (OTHERWISE KNOWN AS
 "SPANK BANK")

cock drop - Im gonna get sooo deep
inside of you. they dont know
what the hell was happenning
or. Im gonna beat you ass to the
floor.

buttmyth - wanting to be inside of
girls anas.
my girl friend is a buttmiss
she wont let me put it in her ass.
she is a myth

handler - babysiter.

Gut Bomb - Heavy Food

P noche → Peunoche tang → Poon Tang
pussy

Cover lots of ground. = traveled far
distance

This is not my first Rodeo

This is not first Contact.

cottage cheese = fat ass
that ass's surface looks like cottage cheese

shot out - fucked up. trashed.
shot pieces by gun
shattered in pieces.
This town is shot out. fucked. destroyed.

Blitz kriezed = Bombed. drunk

It didn't blow my sox off
that wasn't impressive
sox is still on.

mouth Breather.

they are snoring while they are make

Boo Boo

White People Problems

- complaining for no reason

they say OH my God! fucked up!

chugging cock

- the way to get "ahead" in the music industry

GLORY HOLE

hole in wall for
mystery dick suck
ry truck stop or
porno theater!

. monster card -
drunk f*ckin mess!

Con I bum ^off ya - Con I hue
 a fag fag=cig. cigarette.

Friar Tuck
Mark

high falootin' - fancy,
 expensive
 refined.

Detroit Lean - gangsta style.

dingy

ding bat - in 50's
 Slightly crazy - not quite
right. Flighty
 spacey. Angels + Rocks.

Space docking -
 shites in Condom. Put in the
freezer then. Use it as dildo.

American Kobe beef is
from Snake River Farms.
Idaho. It is NOT
Japanese Kobe beef.
 — JoB

put 'em on the glass

when you drive by girls
with large breasts push
their boobs on the
window

Jacob Thiele

pRessed Ham –
when you moon someone
and push your butt
on the glass

Sea otter – When you
take a sh.t, and run out
of toilet paper, So you
have to jump in the
shower to clean up.

Moon = pulling down
your pants &
showing your butt.
Fun time, indeed.

that's
a butt!!

← truck nuts

Bridezilla - A picky woman.
For No reason goes wild me
gets Mad wildgn and before
Her wedding day

S.T.D

Sexually Transmitted

Diesease
Popular in Santa
Barbara and with
CC

flex my
Pecs

show dudes your muscles - LS

chocolate thunder - diarrhea

shit show - Total craziness. disorganize
cluster fuck
 everyone's drunk. - situation

 really drunk — you are shit show

chocolate fountain - to dip your
 weiner in. but usually
snacks at weddings!

I know what he's eating for dinner

 You get the dirty meeting.

. You have place to stay and laid

~~cheese~~ cheese horse - Pass gas.
 terrible fart.
 * horse stable draped in cheese

Role of Eco-Conservation:
If it's yellow let it mellow
if its brown flush it
down.

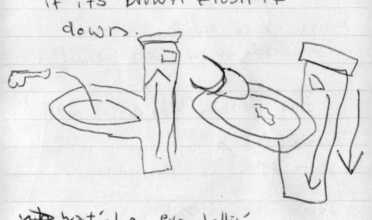

what'cha eye ballin'
what are you looking at
if someone said to you just look
down and walk slowly. get away.
don't talk. NY

foo foo - gay old school
foo foo juice - Perfume for men.

Moose truck - skid mark on your pants

Denver - home of stand up 69.

Epic fail - one thing goes absoloutely wrong.

Anal Intrusion - get ready to do some butt fucking

"Duck Butter

When you finish butt fucking and you cum inside the butt, the new material created with poo and semen is duck butter.
"AKA: DOODOONAISE"

shred - ~~touch~~ touch

I want to shred your cock
Im gonna shred to this song.
Im gonna rock so hard.

moroccan - gambler serch for gold.

busty Broads ← out dated at Hooters.
↑ ↑ ↘
big brested woman chick. baby bebs

 and.
heater - good · fast.
 referencing the base ball
 really good fly Pitch.
that lost song was a real heater.
 a Pretty good Shit.
This song speaks to me.
 I just squeezed out a ~~heater~~
slam - tear that Pussy up.

Aspirate : When ~~it~~ liquid or food goes into
lung in place of stomach
cough cough wrong tube.

Story book neighbourhood ~ th
lots of white. nice neighbourhood.
safe. no colors. safe white neighbourhood.

if you feel scared or unsafe run in to
white person close to you. white = safe

Lefty loosey righty tighty
screw driver.

Q Do you know how to tell if a duck
has soul?

A: Put it in the Sun and see if its
bill Withers ハミスラ ハガーズ
a man with mucho soul.

2 pump chump. - 2 pumps then you done.
2 pumps then you come.

Hack - amateur

these boys are hacking around.
They are being so amature.

stock boy - boys that stock.
put the shit on the shelves
~~the~~ teenager's job.

Mull-gan - In Golf - You get
1 shot per round to do it
over

Scared = Scuured (hip hop)

How MANY hippies Does iT
take to screw in a lightbulb?
- hippies dont screw in a
lightbulb, They screw in dirty
sleeping bags

~~cr~~ cashed — done!

good dead for the day.

~~has~~ do one good thing for a day everyday
• I feel like.
• Walking on eggshell
may nervous. too Sensitive To deal with
I dont want to touch.

2 Top - up - refill. any kind of liquid.
Top - off - shake one off

Agro — super aggressive.

 Henry Rollins on stage.

Dingy - Cove - office
 +
n·rty old dull.

melt down (n, vrb)
inability to perform,
subtle psychological, freakout,
he melted down.
he had a melt down on stage.
 JK and his band melted down in Cleveland, OH

Wrecking shop (v)
- to destroy in any way physical or mental
"these two guys came in and they were
 just wrecking shop all over the place."
- or doing so good

cruising ?
you are single and looking for women.

blast beast - talking a big crap!,

"getting def" - taking a shit.

short for detecating.

leech - blood sucking like vampire.
 taking all the good life from you.

Bare Necessities —
basic things you need . water. TP.

cook with bare Necessities. simple cooking
 s + hx ÷y ⎺₂ ⎮⎺⎺⁊
CHATEAUNEUF - DU-PAPE
 castle of the new Pope
 big celebration wine in France.

Phone it in - ~5% no effort.

he was still not sooo into it but did it
not in to it

dank a bunch of things
awesome. Also slang
for marijuana.

intuition - when you just know
"womans intuition"

secular - not religious.
no xmas trees.

snot rag - kleenex

lash out - attack. yell at.
cindy lashed out at flick.

rSVP - you letting people know you are coming or not
reply for invitation.

Tippy toes — walk quietly
 sneak attack.
411

sike - Just kidding.
 └ psyche

Corn fed - people from midwest
 Indiana, Nebraska, Iowa.
 David letterman is Corn fed boy
 from little town in midwest.

 another meaning — not smart.
 not sophisticated
 cow, beef

Shit show - crazy, shitty scene,
 chaos - negative connotation,
"yo, that was a total shit show"

mind cross — not cool.
 uncomfortable.
 conflict

my mind was crossed

Spank bank — whachadex
 mental "slideshow" of
 woman you've been with/not
 been with, that you fantasize
 about while masturbating.
 AKA "flashcards"

 totes Awes — totally awesome

DICK-Time
the time you put into sex
pixelated
 Jimmy from Toys that kill
over girls can have dick-time!
o grumpy. with dildo

Brazilian - Brazilian wax
when pussy looses all hair
good by pussy hair, pull → yanked **out**

Chestnut - Someone special, a gem.
Lump of coal - Someone shitty.
you are my chestnut - you are special

Kick up a notch - things get intense
when I try to find a crim to slam
I can get up a notch

Salvadoran -
Pupusas - Thick tortilla filled with stuff.
yucca - like potato root vege

Bridezilla - when the bride becom
a monster.
270 -
holy macrel - holy shit, less offensive
way to say.

Woosie or Woos — like a
"pussy" — a wimp

"Turd Degree Burns"
Its when you have too much
Hot and Spicy Food. The Next
day your "Turd" - (Shit) will
Be hot and burn your ass hole.
"TURD Degree Burns" is a play
on "Third Degree Burn" which
is a very serious and painfull
Injury suffered by Fire.
 Adam McKinley, Seattle WA

Bu- Li- Bud Light. Budweiser Light.
 superior drinkability
 fancy marketing.
 easier than Budweiser.

Gamey - taste weired. Rabbit.
 any thing wild.

Down time - The time in a day
I don't do shit.
Killing time.

Raw dog - No Condoms.

Im gonna raw dog the shite out of you.

bone zone -- to have Sex, Sexy time

I took her to the bone zone.

Cannon ball - Jumping into water. balled up.
good for fat dude big splash.

Holla - Talk to later good bye.

10-27-2011 THURSDAY -
LUNCH @ SAN PEDRO BREWCO
SLANG TERM - "CHORRO"
MEANING, "DIARRHEA" - S. COLE

Floosie - a major slut!!

WANDERING EYE ~ ROAMING EYE
LOOKING AT OTHER WOMEN
WHILE YOUR IN A COMMITED
RELATIONSHIP (AN INATE QUALITY
IN **ALL** MEN)

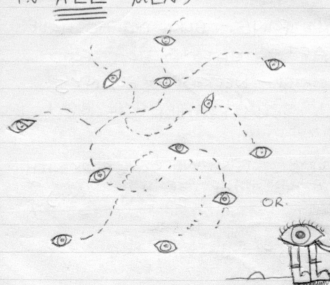

OR.

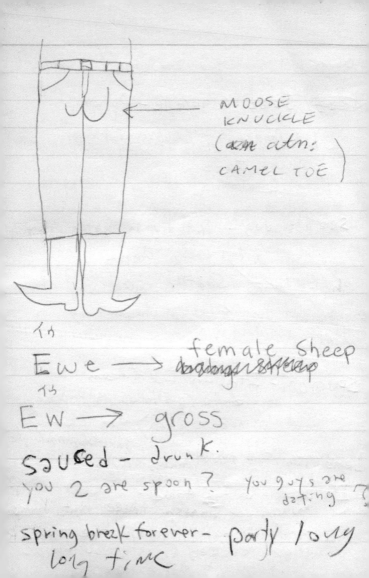

MOOSE KNUCKLE

(aka akn: CAMEL TOE)

Ewe → ~~female sheep~~ female sheep

EW → gross

SAUCED - drunk.

you 2 are spoon? you guys are dating?

spring break forever - party long
long time

You own it— you awesome!

~~Joint~~ Jazz Cigarette — Joint.
You smoke it you wanna listen
some Jazz.

Seattle dog — hot dog in Seattle, they
put cream cheese
from Chicago
↓
Philip thinks Seattle should stop
making hot dogs & stick to making
coffee.

Spumoni — Italian Ice Cream
w/ chocolate, pistaccio, strawberry
Ice cream, also cherry's
grapes, pineappl
at
Lem's 75th South side of chicago nuts

• I'm throwing in the towel—
When you finish three hot link
and you can't finish the Bar-b
sauce soaked fries — you throw
in the towel.

Bacteria Build Up -
 When mayonaisse based foods
 are left out in the sun
 when it's °95 out ...
 Happened at Hillbilly shot gun wedding
 you dont see spuumoni' at ~~the~~ hillbilly shot gun
 wedding.

 5:55 goo foo.

Jenny: Im sooo hungry

Phillip: Jenny you should eat some rice at home.

Jenny: Don't tell me to eat rice you racist

Phillip = white Jenny = Korean.

 ETA - Estimate time of arrival
 Smooch - Kiss.

Hot doug -

Smoke screen — fart.

back on the market — newly singl
I'm selling again,

what ai are yinz up to?
↑
You guys / y'all

- You are sooo far away from Jeses christ
You are worst Daughter / son

Gun ships - ~~Big boobs~~

Big Boobs
Breasts that point outward like
weapons,

off the chaine - amazing

LA
↓

How many Silverlake hipster
does it take to screw in a
lightbulb?

1) It's a reeeally obscure
answer, you probobly
wouldn't understand!

what's up pizza baby?
ever had your crust stuff?

toll Donkey— geting f*cked up
did you see Jeff? He was full donkey.

Bump - To get a little more
cocaine or speed. To "re-up"

Pull a train! - To have more
 than one guy or girl
 fuck the shit out of
some one, one after the
other. IN turn!

~~BUKKAKE~~ -

Honk for freedom 69
- honk your car horn
 to celebrate your
 freedom

CLEAN AS A WHISTLE"
(VERY CLEAN) German -
 ACCENT - VISTLE

Shlepa (~~shlep~~ - (Sh'-lēp-Ah)

Person who is major loser
 {example: That guy sux
 he is a shlepa
ex: Asshole, Fucker, Prick

Pocket Pussy - TOOL used
 to help Jack off. You
 can keep in your pocket

GENITALS - DUDE or CHICK STUF
 secret part of human

POO POO INVADER - the anal pock
 pussy
 anal ver of Pocket Pussy

Man juice - power to
 controle the
 world. with
 one mans cock.

ood
coma = when you eat too much
 food (like hiro) and you
 cant move.

fam - family
 rents ~ family cause they are
 paying your rent

steamroller = wake someone up
 by rolling over

Break out (Leave)

E. L. - (even lower)
i.e. even lower than
the D.L.

Herbicuticals (pot)

fancy (to Like) use only in!

bird (girl)

jailbait (young girl)

superphonic (really really good)

I was sleeping in the
yurt last night

means drunk

you puts deep

Break out (Leave)

E. L. (even lower)
i e even lower then
the M Th...

Herbieuticals (pot)

fancy (to like) i seriously

bird (girl)

jailbait (young girl)

supaphonic (really really ...

Shaunga ; Trans...

I was sleeping in the
gutter last night.

means drunk
gutter — dirty, filthy
 really
gutter punks — Dirty punks smelly

Yo nuts deep.
 nuts deep up in

Hey Im nuts deep up in — Im here
when you walkin to a party

— you can say that again
— god damn right! grandma

do rag:

like a bandana. Wear it on your head to protect your hair-do.

hair-do - Hair style

michael has dumb hair.do

"Rolling with the Homies"

- Hanging w/ friends -
 SEE CLUELESS

~~$5.00~~

"Barfing your guts"

TO - throw-up!

The Thermals ~ Portland, Sub Pop.

eclipse - when a moon or planet
blocks the sun.

cooked - Done. ready To bed.

stuffy - Humid. ~~Air is~~ closed in
 Air is not circulating
 Some one who square - up tight.
 dude who wears any suits.

Gravel - rough road with lots of
tiny rocks. not like concrete which
is smooth.

choo choo train

Full contact

lo people fucking at same time no spa
making circle

Last night

Mr

Vo ist herr toaletten?

GERMAN: WHERE IS MR. TOILET?

Spitting Distance — super close

Badonkadonk (butt)
 - Big, nice, round, and
 ~~aste~~ pleasing to the eye.
 (and probably smells nice)
 * can be shortened to
 "donk"
 short ~~for~~ for donkey (ass).

Boot juice — the juice
that comes out when you buy hot feet

JOJ - Jack off Jelly
Dove, Hotel lotion.

ミナイフス-ミナップス

shucks - shite
shame shame - ⟨drawing⟩ rapid
Hero = cool finger
 motion

EEL SKIN WATCH

Fake Taco
Balls and GRAVY
~~Balls~~ Cahoné Guisada
 cajone ギサダ
 ロオーネ

Migas - eggs on tortilla. beans - Poteto

Rollin Deep.

going somewhere with
your possie (Friends).
gangsta style

"He's a bumout!"
He doesnt ever hang out...
he's lame!

Buzz Kill.

your Drunk or High
and someone is annoying to
you and brings your Buzz
Down

UPPER DECK :

WHEN YR. AT A PARTY
AND YOU DON'T LIKE THE HOST
YOU SHIT IN THE WATER FILLING
PART. NOT ~~THE~~ THE ACTUAL
TOILET PART.

"SKEET"
↳ jism, ejaculate, semen.

"SESH"
when on annoying dude
or phony rocker. says
you should jam together.
MAKING FUN OF THAT TYPE
~~OR~~ OF "ROCKER", YOU SAY...
DUDE WE SHOULD ~~TOTA~~
TOTALLY "SESH"!

ROO — pussy: as in kangroo from
the land down
under.

loose as a goose" - had a few drinks, a little drunk.

Tipsy.

Take the Cleveland Browns to the Super Bowl = (Taking a Shit)

Cleveland Browns = Football Tea
↳ = Color of Shit

Super Bowl = Final Football Game
↳ = Toilet Bowl

we negociate Chocolate hostag
 situation

⊗ Taste of your own medicin
 you get what you deserve.
 generaly bad to say.

pony – really good fashion

laid (layed) back ——
(easy)

"with my mind on my
money and my money
on my mind"...
* Snoop doggy dog.

this is smooth – (o.k.)

evidnce – proof

Ron Jeremy – Porn star People said
 Harmar looks like him

Tunnel vision – can only see one
 thing at a time.

Duds — men's close

Threads / good looking mens close

check out my threads

Digs — pad fly Digs man!
 some one lives in nice pad
 fancy

[I'm gonna keep it in my Dome. dude

[I wont forget

"Put the chrome to the
 dome"
 Pistol to the head

— you are speaking my language

— thnky dude
 Thnks alot we are on the same page.

Montezuma's Revenge –
"burning asshole after
eating spicy mexican food."
Montezuma was the last
Aztec ruler, killed by
Christopher Columbus.

hockey squat –
How Sammy poops on tour.
Squat so you don't touch
toilet.

Top notch – the best.
 High Quality

How was pasta? top notch.'

This is the Jam – The hot track
 this is the good song
when you hear Harmar Superstar.

"Coke off the Boner"
Snorting a line of Cocaine off of
some dude's hard on.

big ballin' ~ rollin hard.
rollin deep
(money makin bitch)

shit fire! — damn! wow!

sheeite ← Southern draw
accent

are you "the catcher in the Rye?"
= Do you have drugs?
because, in the book, the lead
character's name is
"Holden Canfield"
* holden = "holding"

Which means the same.

crucial - cool. ~~are~~ awesome

hey man can I hold your key?
 ↓
 borrow

STD - sexual disease
 weiner fall off

ow many emo kids does it take
o screw in a lightbulb?

1 one to screw it 10 to right
a zine about it

How many Riot Girls does it take to change a lite bulb?

Who cares why didn't she make me a sandwhich
or (this answers funnier) Two. One to screw it And one to suck mud

How many straight edge kids doe it take to ~~cheeg~~ screw in a lightbulb?

None, they don't screw.

Tips for unemployed Roadie.

6 Degrees of Kevin bacon

Taquito: small taco

Canadian Tuxedo - Jean Jacket and Jeans

Elephant Walk -
When fraternity guys are initiated they are forced to do many crazy things. The elephant walk is when they crawl around in a circle naked holding the person in front of them by the cock. What a bunch of ass holes

Take a load off - take a seat and relax

awkward- doesn't fit
weird-

ol Rocky top / knoxville tenness

Rock in the boat- making situations
unconfortable

I rule - Har Mar Superstar

① KNOCK KNOCK -
② WHO'S THERE?
① DAVID LEE ROTH
② DAVID LEE ROTH WHO?
① ... THAT'S SHOW BIZ!

MULLET

ALSO: "SHFELBY"

SHORT ᴬ FRONT LONG ᴬ BACK
 IN IN

ALSO: SHORT ENOUGH TO
WORK, LONG ENOUGH
TO ROCK

ALSO: "THE CANADIAN
PASSPORT"

money food - most
eypencive. food on
Table.

when you are full—
make sure you eat all
the money food at the
end... (get your money's
worth!)

"
🙂!
yum!

. ex. skip rice, go for meat
 ex. skip the tortilla
 go for the cheese

MANVELOPES—
MALE BREASTS THAT LOOK LIKE
THE TRIANGLE PART OF AN envelope
NIPPLE STAMPS—THE nips become
———— STAMPS on the manvelopes

"Raise Hell" cause trouble
 in a very fun wa

Literally: Hell on Earth

Stink Lines"

Trasher

visual
represent
ation
of stink
on a drawi

urine page

"pissed" US → angry

"pissed" UK → drunk

"pissy" US. uptight - argumenative

unhappy

N.C. → watercloset → toilet. UK

'iss like a racehorse — Big Long

Piss

Squirrel tank (cursive term)

— someone who can't hold their

pee

"Buck wild" — Extremely Wild

(perhaps naked-

wild)

"let's get buck naked and Fuck"

(butt?)

— source unknown

(ask Har Mar ★)

loo - toilet
Piss - wee
Pissed - Drunk
Wankered - Drunk
wank - jerk off
Cunt - Bad person (insult)

butcher's look = look
have a butchers - have a look
trouble and strife - wife
apple and pears - stairs
dog and bone - telephone
knackered - tired
kip - sleep
piss off - leave me alone
innit - After any sentence (slang

eg: Yeah blood innit.

blood — brother / friend

Ah to be sure, to be sure
 (Irish) Yes!

Spud — potato

chips — fries

Skunk —⎤

Weed ⎤

hash ⎬ marijuana

dope ⎬

maryjane ⎬

draw ⎦

blow

Joint — marijuana cigarette

high — ⎱ high on marijuana
Stoned ⎰

ish — around a certain time
 eg - 8ish. (around 8 o'clock)

Flashy — wearing crazy cloth.
people watch you.

Yes — Aye scottish
know — Ken
"I ken Mike Park"
No — Nae *—
don't — dinnae (pronounced — Din—
lady — Wifie
Man — Mannie
girl — lass, lassie, quinnie
boy — lad, loon
thank you — cheers, ta
mum — ma
dad — da
my — mah
Clothes — claes
going — gan
"I'm gan shoppin' for Claes"
groceries — messages

Q:
ve you ever felt a man touch
another man?
A: NO
REPLY: NOW YOU HAVE!
"DUM" "DUM DUM DUM DUM

Scottish people = most unhealthy
people in all of
Europe ("sick man
of Europe") - bad
food, too much
drink, too much
smoking. (no
exercise!)

Bron stocker
Drakule

Orite Jimmy - alright friend?
scotland
scottish

tattie bye jimmy - goodbye friend.

(3) What do you call a deer
a. with no eyes?

No idea

b.
(3b) What do you call a deer
with no eyes and no legs?

Still no idea

c. What do you call a deer
with no eyes, no legs and no
cock / dick / willy?

Still no fucking idea

Police

Bobby, Rozzer, Fuzz
Filth, Pigs, old bill
Babilon, Plod
Copper
Bobby on the beat - Patrol

PC - Plod

BEN DOVER = BRITISH PORN
 LEGEND!

COCKUMENTARY!

stares in his own movies.
british housewives. People
at work, documentary style!
 ↑
 :)

spud — potatoes — Scotland

RELEASE THE HOUNDS — take a shit

'Making a deposit' — take a shit

hen — means chicken, but in
↳ Glasgow it is slang for
WOMAN

How yoeee dien hen.

'50/50' ↳ half fart
'shart' half shit

Totty — hot lady / small

'paint the town red
— Go out and part

MAKE A WISH Fandation —
when something or someone
Has sex with you out
of pity

ON DECK — THE DUDE
THAT IS FRIENDS
WITH A GIRL BUT IS
SECRETLY OR NOT SO
SECRETLY WAITING
TO STICK IT IN HER.

hack it — Take it
— Deal with it

Can you hack it?

hack — not quiet top notch,
no good, not cool,
shitty tattoo

Chris Head loves Wagamama

Wagamama is a Japanese franchise that is common in Europe, UK and Australia. Chris Head, guitar player of Anti-Flag, eats at Wagamama any time he is anywhere near one while on tour. Oddly enough, when touring in Japan he won't touch Japanese food. He eats "American" room service three times a day. CHRIS HEAD ONLY LIKES JAPANESE FOOD MADE BY HONKEES.

CRABS —
Sexually transmitted
bugs in pubic hair

Puberty — when a boy becomes
a man.

yinz — you guys.

e nat — and that

(down town)
yinz guy wanna go don ton
enat and git some chipped
ham.

"I'm so drunk" or "I ate so
much"

= I'm such an ox!

"GOLDEN SHOWER sexy fun with piss!

"IRISH SHOWER"
 Washing your body in a gas station bathroom -

"French Shower"
 Putting on cologne to cover bad smell.

"TAQUITO"
MEXICAN FOOD.
DEEP FRIED, ROLLED TACO

"DIRTY DEED"
PARASITE UNSPOKEN ACTS
THAT ARE USUALLY NOT FOR
POLITE CONVERSATION

BAW BALL

Nee Bother – No Problem

Scran – food.
— Aberdeen

Jaw bag – testicles – can
to piss ↑ be used as an
BALL BAG insult.

– Someone who likes to
 tea-bag be tea-bagged

Jawjaws – someone who likes
 to put balls in their

fanny = vagina! (mouth
 (not ass, like
 in USA)

jobbie = shite

 balls.
 ↓
scrote = short for scrotum.

vajayjay = more polite
 word for vagina.

Cold Turkey - Stop Smoking
No Help

Squeaky Clean
Choir Boy ⟩ Good Boy
No Love Hotel

Big Cheese = Big Boss Man

HomeBody - Stays At home ALOT.

PLASTERED = DRUNK

I was Plastered in Germany

PRODUCTION MEETING = SMOKING WEED

information super highway — intern

Zing! a jolt or sudden
 burst.

high — stoned — out of
step - happy — feelin
good.

hyme do?? - "why do i do what i do

PUNISHER — SOMEONE WHO WON'T
LEAVE YOU ALONE.

 could be anyone
 fun.
 you can't escape

o schlag → order a shot
 of goldschlager (cinnamon
 liqueur) for someone
80t who doesn't want it
proof or doesn't know you
 are ordering it, and
stronger he/she is obligated
than whiskey to drink it.

 "you've been schlagged"

stuffy - stuck up...
uptight implying a
certain aristocratic
quality. like the british
wedding w/ Shacho.

Hillbilly Shotgun wedding.
when yer redneck buddy
marries his ~~highborn a~~
woman cuz shes pregnant
implies urgent solution.
lots of mayo at wedding.

Potato salad. ham salad. egg salad
Coleslaw. shrimp salad. (mayonaise + shrimp

FLOG THE DOLPHIN - MASTERBATE

Did you pop and stretch
your penis Today?

(stretch your boner)

To bend your boner.

chris
← #2

This drawing is how
he explained his morning
wood stretching exercise

"WORD ON THE STREET"

Gossip or what we've heard others talkin about.

"CHICKEN HEAD"

A LADY ADDICTED TO CRACK. SHE SHAKES AND BOBS HER HEAD LIKE A CHICKEN

"SCARFED"

TO EAT QUICKLY...

REGGIE SCARFED THE SANDWICHES...

"fly on the wall"
being in a room when
nobody knows you're there

decompress - chillou

"Talk your ear off"
someone who talks and
talks to you until you want
to throw up.
Neil's Dad

she wears the pants

Pussy whipped
she's in charge. she's the boss

you want both thing but you cant

he wants his cake and eat it too

he wants the best of both worlds

between the a rock and a hard place

you are in situation that you cant
 get out of
no way out

he drops f bomb's alot.

he says fuck alot.

LSD - Lead Singers Disease
universal affliction suffered
by most lead singers of bands.
symptoms include: lateness, big egc
alcoholism, mood swings, may
be communicable

You're so good looking"
when someone sneezes) from Sienfeld

or cover your mouth.

HUSTLING — PRETENDING TO BE BAD AT
(in the pool sense POOL TO MISLEAD SOMEONE

strategy Denny is the hustler

Nappy Dugout — Hairy Vagina

While watching "Fast Times at
Ridgemount High" ~~David D~~
~~said openida, big al to~~
~~the~~ When Jennifer Jason
Leigh is getting fucked
in the dugout, David David
said, "get in that
nappy dugout." "In the
70's chicks didn't have
their vaginas." - Fuzzman

empath
empathy - you ~~are~~ can
feel the emotion
of peeps around you.
it enters your body.

¿HW-MAE! (LIKE THE
DUMPLING)

HELLO!

Detroit Slang

Hey Chauncey!

How big yo dick!?

Means "Go Pistons!"

Auhh Hell no!,

false hope - wrong idea.

dodger good - muy ~~goo~~ bueno
best of the best -

//////////

DICK-WORTHY:- women

is good looking
enough to be
be sexed
by you

bi-polar :- depressed and one moment
very happy.

Rockey Mountain Oyster

ice cold a balls on your fore head.
Carlos's favorite.

Tito Story
— Dirty Walt would suck
on his joint and lick it
like it was his favorite Dick!

"Boneing"

Stickin it in!

McGangbang

Two Sandwiches
one 99¢ chicken Sandwiches
one 99¢ Double cheeseburge

⊖ - Double cheese
⊜ - chicken
⊝ - Double cheese

All for 2 Dollas

You "coagulate" them
put them together

Snow Ball -
You cum in your Males
mouth and she spits
it back in your mouth

Contact High - Getting High
by being in close contact
to People smoking marijuana.

Marijuana - weed, pot,
Reefer, herb,

dick heavy - horney.

empty my dick - Pee

"GOOD HANG DAY"
def: DAYS WHEN YOUR DICK
LOOKS BIGGER THAN NORMAL

EXAMPLE: IN THE SAUNA US.
COLD OCEAN

"CRUST - DITCHING"
NOT EATING PIZZA CRUST +
LEAVING IT ON THE TABLE
FOR YOUR FRIENDS TO
DEAL WITH.

- Stood him up
- king had to hang out in the bar
 because Solo Mission because
 his Date canceled.

Wired - Awake for too long
 but can't fall asleep.

False Alarm - You think you
 have to shite — then you
 sit on the toilet. And
 nothing comes out. False
 alarm!

gel ~ smooth connection
 Hennessy's cock is too
big + chotto pointy + the
guitarist's asshole is too
tight so you need put gel
around it for a smooth
connection.
(get along) feels good - smooth -

sidler.
someone who creeps up on
another unknowingly and often
unwantedly. often a punisher.
to surprise another by
sneaking up on them.
to sidle.

~~take~~ dick

she rode the D train to Pound to

get it on : you fucked her

[chip the concrete
 you gotta Piss really hard.
[Big Thrust.

shoot biscuit — take a shit

SPITE = OUT OF SPITE

if there were one water left and you were thirsty and i wasnt but drank it only so you couldnt, that would be spite.

no Logo No go go

if no Sign on the freeway don't go go. ~ Jimmy the Retard

1 cursewords - fuck. shit

piss. bitch. cunt. God damn

slut. cock.

hode = penis wider than it is Long. eg.

(Cougar - older women fucks
 young dude. Pounce!)

hobo - homeless people.

over the hill - You old.
 after 40 ~

Put your stupid comment in
 your Pocket.
 shut the fuck up!

Grab - food How's grab.
Ghost Cousin → Tristeza
Hole Brothers - two friends who
have had sex with the same
girl, who are still friends after

it happens when you know People for 12 years

Get 'R Done

do it, good luck.

accomplish
something

NUGGETS OF WISDOM:
SMALL, INTELLIGENT BITS
OF INFORMATION. LIKE THE
TEACHINGS OF the BUDDHA.

Punisher: (Alternate definition)

An overzealous fan who
won't let you leave and won't
stop talking to you about
your band. You want to
be nice but they are

extremely annoying
They are usually drunk
It feels like a Punishment
To talk to them
Also:
 Frank Castle
 or being in the WAR ZONE

Double Quarter Fish
Pounder w/Cheese + Filet

+

McSurf and Tu

=

—

7 days with out beef makes
one weak (week)
TEXAS!

"SHOW IS" - slang
for: sure is. a sarcastic
reply to something
that is obviously
not true, example:
"~~it~~ the killers
are good, show
is!" best when
exclaimed
origin: searcy, AR,

BLUEBERRY FIST - masturbating
with a broken hand.

~~Rin~~ Ring sting
burning bong (Anal)

CRACK DOWN
TO ASSERT AUTHORITY
Sandiego doesn't crack on the Parking

Decompress - chillax
chill out · relax
unwind.

Mi ombre es Hiro
my name is giu

Me puedes dar un vaso con agua
Can you give me a glass of water

ら　　ら　ィ　ェ　ネ　　　ら　　　が○

LA TIENE DE BURRO

you have donkey cock, big cock

Dial it in — make it right

make things happen
make situation better

DROOPY ASS (Drew PS)

Holiday horney

(sweating bullets
(super neourvous
I was sweating bullets

Asteristico

butthole

Rat bastard = Slime ball

derogatory – calling somebody in a name
negative way

Take a powder
Scram
Amscray = Leave
Vamoose
Bust out

Road block – getting in the
way of another's happiness
(pursuits)

Road Dog – Person who
is very good
at ~~the~~ touring.

Street Pizza - Your skin
after crashing on street

Road Rash - Same as street
Pizza

its
Toast - Done.
 got beat up.
 no mas -
 you are toast. You are done.

NOT PLAYING WITH A FULL DEK
VERY STUPID.

SHARP AS A BOWLING
BALL - PRETTY STUPID

too cool for School -
too much attitude -
 Sometimes in Cha cha lounge -

Cheesedick — Meathead
who thinks he is a god.
Has all the moves and all the
apparel. Looks "cheesey"

uncognito — under
cover, under the radar
invisible, behind the
scenes
he showed up in uncognito.

Motor Boating — a person
puts their face btwn two
boobs and blows out air o
"zerberts" the skin btw
while the boobs shake
side to side.

fuck This Turkey
TCB.

Flush — you call "flush"
oct when you fart in
a car and need someone
to roll down a window
to air it out.
*Cursive's Van

Dicked up — drunk

hungry unicorn — when you put
a strap-on dildo on your
forehead and fuck a guy in
the ass while you suck on
his balls.

"Bro Down"
Hanging out with friends.

"Bro Off"
People you don't ~~like~~ like are
hanging out.

"Un Poco"
like Poquito
"Do you speak spanish?"
"Un Poco"

Doorbell Ditch - ring the bell and
 Run like hell.

= Ding Dong Ditch

Pass the Hat = collect money for the
musicians by handing a hat or
bowl around the room

Crotch Rot ⚡ – sweaty balls
or "SWAMP ASS" irritated "

Big Ass Brawl = bad fight.
 mucho danger

Go Dutch - split the bill

 Dutch People Always split bill
 stereotype of Dutch peops
 They neve buy you ashit
 want to go out for dinner?
 lets go dutch!

Dutch treat – I pay for myself

penny pincher

- super greedy ass peeps who try to keep every (1¢)

hypocrite - person who says "don't do somethin BuT ... THEY DO iT!

You shouldn't smoke.

hand solo - shake one off

Han solo

whiner - Complainer

dude - Do you want an In-n-Out
Burger ?

chick - No.

dude - How about just the
In-n-Out ?

24 carrots - very Good!
off the hook
muy bueno!

Hiro ate

in one meal !!!

1,330 Calories	61 grams of fa

Snot Rocket
when you have snot
then you blow out of your no
You blow the snot out of your nose without

the tissue (country hankerchief)

Jungmal — really!? in korea

Jock itch — sweaty balls
ATHLETES BALLS fungus on your balls
A.K.A
ATHLETE'S SACK itchy balls.

ENGLISH SLANG... WHATEVER

HOT TO TROT..? HOT TO TROT!

1) LOOKING FOR A MATE.
2) HOT (LOOKING FOR LOVE)
3) FAST COMPANION FOR
 LOVE MAKING

DIVORCEE... TONIGHT FOR
FUN IS - HOT TO TROT.

WIFE

EX: HUSBAND

NEIGHBOR

The taint
the area between the asshole and the
balls. It "taint" your ass and it
"taint" your balls!

CHODA yoda
yodA's, chode Kudi

Punk Stew -
food that is generally
offered at shows in German
- Ingredients unknown
- herved on overcooked noodles

바보 (Bah boh) - fool
Ai - goo (Oh no)
Oh - moo - nah (Oh no)

그래서.
Comment va tu - How are you

Cava - good.

meci - Thank you
aurevoir - good bye

Saves the Day - make things good.

Fat Albert Saves the day

hollow leg- an
empty leg to store
food

Trim - pussy

2 in the Pink (Pussy)
1 in the stink
(butt hole)

Russian

Hello - prevet

Thankyou - spaceeba

humble - you are not very showy
not like checkme out
Ive got big cock or big mone

Looney — Canadian dollar coin.

Twoney — Two Canadian dollar

ṢUCK YOUR URETHRA DRY

michael Gerry

no frills. no Bull shit.

Onica sez. did you totally kicked your
 cold?
bye bye cold. no more cold.

taylor ham – exclusively NJ
greasy food

egg in a hat
egg in a hole
one eye whilly

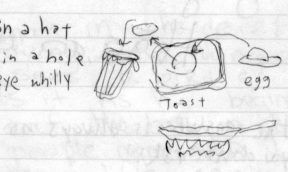

Toast

egg

you gotta get your cock out of
your mouth.

stop shitting me. shut the fuck up

pot luck – party when you have
to bring some kind of food
dish (salad, pasta, etc)

Hickey- from a heavy make-
out session, sucking the neck.
bruise.

Stephan→ ←hickey

M.I.A.- Missing in Action

coast to coast- from
the east coast to the
west coast

livin it up- having a
good time!

are you posh? broh.

-for sure-

detox- getting healthy.
usually means no alcohol no caffeine
all healthy foods. no meat!
could be used for alcoholics

Lingo continued

* 6-RIDE → car
* →

* cash - money - bills,

money

* ta-ta's — boobs

NET. BUTT — LOOSE POO-POO
SWAMPASS diajerea
 Diaharria

fully loaded - Ya-els car.
car Has Everything. dual climate control
navigation, satillite Radio. Parking assister
6 CD changer, Leather. fancy wood. sun ro

marc 2

San matero - when you moved
back in w/ your mom

ghost shit — when you
take a shit and wipe &
there is nothing there.
(the best kind of shit to take)

Saab — Saab-a-dabba~do
Yo-el's fully loaded car.

I feel very drained

no more energy kicked.

Pooped

HEY BRO'. — said by a knuckle to your.
head.

STEVE & KEIKO — WHITE SENSITIVE GUY —TEACHING
ENGLISH
DATING A JAPANESE GIRL

TONROL - Annoying, Americans who insist
on Speaking bad Japanese

Herion Heroin
 "CHIC"
Streak "~~streak~~"
"junkie models"

"Animal
Style"
IN & OUT
must have.

slayed – kill somebody
 in music terms: slay people
 with rock n rolled
 "we slayed the audience"
we Rocked./ audience over Alive hotDog

Footsie...
(flirting with feet
under th table)

FRENZY - CHAOTIC SITUATION
PARKING LOT HOT DOG eating
frenzy! Detroit style

"fabulous Ruins of Detroit"
T.M.I = too much INFORMATION

FALSE AlARM: NO problem
its gonna be ok.

Too ~~much~~ much Rock for one hand

Danny Panny — Dan from
 Alkaline Trio

torn up — bad condition
worn out / getting busted

I gotta do some math
it takes me a while.

beef it up — make it more
 powerfull

Problem

I want hear Your Problem

they Rock with ~~their~~ r unbridled fury

~~they~~ they Rock !

Prego Yourwelcome
gratgi thankyou

its casual — not a problen

~~the~~ fun bags — Tits
Let's make like a Peanuts butter
Sundwitch and Jam

~ Lets go

We are on the way up to Portland

Stubborn — your way is the
right way in
bad way

Gimmick — when Sammy Dresse
up CAPTAIN

Tomylee's Drum set going
flying around stadium

taking of
his clothes

chaser — drink (beer) right after hard
liquor

Q: whats orange and looks good on
hippies

A: fire !

Rock out with your ~~cock~~ cock out
you have good time
Idiots out wondering around
I Owe the world ~~china~~ an Apology
 I O W A

lumpy — tired lazy

I know Vegans who won't
have oral sex because
eating animal Products

Panty_n_ raid — steal girls
 under wear
~~fact~~ — makes some one ~~feel bad~~

Tact - you stink soooo bad now
but instead of saying that
~~that~~ I say you can take a
shower A tonight we are in hot
 because

tact is saying something
hard in a Nice polit
way

. Jez you have no tact man!
 get you shit together sister.

. n minutes in heaven.
 2 people in closet then Probably
 make out.

Pigeon - toed - feet point
in when you walk
like bird

fiend - monster, somebody who
addicted for something,

mark + Jon total coffe ~~fin~~ fiend

(I would = I'd)

" I suck your dick for shot ot
espresso

numb nuts — idiot, grendpa
Grumdahl
used to say

~~Poke~~ poke your eyes out
when girls nipping out

WI (cold weather indicator)
(hard nipples = cold weather)

facitious

mullet
- business up front, party
 in back
 missouri compromise
 Canadian passport
 soccer buddy

Q how many straight edge people
 does it take to ~~screw in a~~
 change a light bulb ~~light bub bul~~

A: Straight edge people dont chang
 anything

Q how many skin heads does it
 take to change a light bulb

A. one hundred, one to screw it
 and 99 to back them up

under garmEnts - under wear
bra.

I will ~~fired~~ fire it up

just start it

charlie horse - ~~charle~~
 sore muscle. or ~~horse~~
tight muscle.
when you punch someone
in the arm and you
give them a charlie
horse then you "connect"
"oh you connected dude.

cock block/
salt in my game —
when you want to
be with someone but
someone else asks them
out the they put salt
in your game.

up in the mix — with
lots of people at
one time
like at a party.

it's getting brisk out
here —
the weather is becoming
cold or chilly.

Spicey — sexual. hot mama
adjective. spicey babe.

raw soybeans —edamame.
fresh soy beans with shel

he fell off the wagon

example: ~~●~~ Nate was vegetarian,
but he started eating meat again,
so Nate "fell off the wagon."

butr face— body is very hot
but face is not so Hot
ex ← but her face!
 (is nasty)

← Hot
body!

Can I buy your breakfast

If you wanna get score,
 (don't do it for real)

commitment — you gotta work
 every day no matter
 what,
 you gonna do it no matter who

overload — too much
 much too much

chipotle own by mcdonalds,

naseous — you feel like you
 gonna puke

whats up with that

mushy — Tired, Lazy.
 Lumpy.

hiro's going to town

~~X~~ doing extra good

. Dave gatchel is going to town
 on his Drums

~~y~~ yank — american's

 fucking yank

eggs benedict — ~~xxx~~ hollandaise
 sauce

Feisty — picky in the sassy way

cats are Feisty.

Those clothes look great on you
they look even better on my
bed room floor. ♡

when chicks attack on fox
smoochie smoochie
~~kiss~~

. a ccomplished - successfuly
 finished

~~トライフリン~~
Triflin - its a phobrem

dont be Triflin my hot dog.

cheese ball - Somebody who like
 Titanic.
Some body who ~~like~~ likes cheesy stuf

I love you sooo fucking much

I could shit.

string bean — skinny

butt pirate — some one who
butt fucks

booty buglar ↗

booty call — some chick call
you say "can I come over"
its started in Disco.

enthusiastic — excited about
doing something
full of life.

tuilet - toilet with southern accent

Pee-kan - toilet

shitter - toilet / pisser

inhale - take in somke into your langs

Dank - good weed

~~schwag~~
schwag ⟶ bad weed.

grissomz - best kind of weed

blotto, soused - Drunk

gold digger -
Someone who dates a person because they have mucho $$

~~blts~~

[blessed in the chest
[big guns

cock rock ⌐ really bad
butt rock ⌐ metal

Potty mouth — you speak Dirty
and swear.

Party in your a mouth — blow
browjob.

Preppy — normal people
They like name brand

loaded — Drunk.
— also "very Rich"

I Love when guys check out the
basement

Clowns always cry inside

shmoozing — getting to know
people.
conversating

Knob: John Q. Roadie

dumbass

I'm on seafood diet
When I see food I eat it

good joke . but dont' tell it to
any one under the age of eighteen
or to anyone's mon.

DIVERSITY !
↳Live through it !

See you later, アリイーター—
① in a while ワニワニ

Q where do you hide money from hippie

A under the soap.

Positive Reflection — like a mirror
energy you put out will come back to you

? ripped it up

<u>Sub'</u> - <u>sonic</u> - lower than human
ears can hear

<u>Pisser</u> - a bad thing.
my car broke down, it's a pisser."

<u>wicked</u> - awesome, cool dude

Tubular - ~~killer~~
fucking wicked fresh

<u>grim</u> (v.) to make one "bummed
out"
He was all talking about his dead
cat and totally <u>grimming me out</u>

DCR - PCS

ope - "that shit's dope"
means "that's the shit" or "supercool"

if you kill some body

I'm gonna ice you

That dude got iced

~~Put you~~
Tonight! Put you on ~~the~~ ice

You gonna sleep with the
fishes

Fit you for some concrete shoes.

~~I'm gonna C2B You~~
I'm bouts to bust a
cap in yo ass

dope - "that shit's dope"
means "that's the shit" or "superior"

It to. Kill some body

I'm gonna ice you

that dude got iced

pot pop

Tonight!. Put you on the ice?

You gonna sleep with the fishes.

Fit you for a some cement shoes.

I'm gonna 'Do' you

I'm boutta bust a cap in yo ass

"How 'bout a knuckle sandwich
and some hawaiian punch?"
(i'm gonna knock you out)

off the hook — going crazy

you off the hook —

Put them on the glass baby
"Put your boobys on the glass"
things to say at booty bar

check out ~~y~~ your
quotes. & things you says.

blast a dookie
Take a dump
Take a shit
Take a Grumpy

After randomly winning an all-expense paid trip to the U.S. through a raffle at a Tokyo Department store I began planning a trip to tour and photograph with my favorite bands.

At first I could not speak English at all which was so frustrating because everyone was cracking jokes and having a riot of a time on the road. So, in order to participate in the all of the fun moments in the van I started to collect various jokes, phrases, and slang words in my little notebooks. Thank you so much to everyone who was part of the journey!

-Hiro Tanaka

THANK YOU!

Ageist, The Album Leaf, Alex Stassi, Alkaline Trio, All People, Amphetamine Reptile Records, Amy Boyett, Andrew Jackson Jihad, Anniversary, Antarctigo Vespucci, Anti-Flag, ARM, Asianman Records, Attack Formation, Babes In Toyland, Baby I'm A Star, Birthday Suits, The Blind Shake, Bomb Shell, Bomb the Music Industry!, Bottom of the Hill, Boxes, Buddah Ryan Matthias, The Busy Signals, Butcher Bear, Capital! Capital, Carlos Morera, Cave In, Cheap Girls, Chotto Ghetto, Chris Candy, Chris Farren, Christine Mackey, Chromatics, Chumped, Classics of Love, Combat, Compound Red, Cows, Cursive, Dan Monick, Dan Papas, Dan Potthast, Daniel Takahashi, Darkest Hour, Dillinger Four, Dirty Preston, End Transmission, Exercise, The Faint, Fake Problems, The Falcon, Floyd, Freedom Fighters, Fuzzy, Matt Kopp, The Good Life, Grotto, Grumpy's, Har Mar Superstar, Hard Girls, Her Space Holiday, The Hold Steady, Hot Water Music, Icky Blossoms, In Corridors, Jeff Rosenstock, Jezrael Salisbury, Jon Lyman, Katie Ellen, Keifer Matthias, Kitty Kat Fan Club, Lake Street, Laura Stevenson and the Cans, The Lawrence Arms, Lemuria, Lifter Puller, Lucky Jeremy, Marijuana Deathsquads, Marked Men, Matt Kurz One, Matt Owens, Mayday, McCarthy Trenching, Mickey Finn, Mike Park, Minus the Bear, Moon Rats, MU330, Neil Linn, The New Trust, Nice and Neat Record, Nick Walker, Nick Zinner, No T-shirt, Ogikubo Station, Out of Order, Peelander-Z, Poison the Well, Portugal, the Man, Pretty Girls Make Graves, The Promise Ring, Ramen Kazama, Rip City Santa Monica, ROAR, Rocket from the Crypt, Sanawon, Sean Na Na, Selby Tigers, Shermer, Shinobu, Slow Gherkin, Song of Zarathustra, The Soviettes, Sperber sisters, Steve Aoki, Stub City, Sundowner, These Arms Are Snakes, This Machine Kills, Thrice, Thursday, Tim Kasher, Tim Teichgraeber, Tito John Hagler, Toys That Kill, The Treasure Fleet, Triple Rock Social Club, Tristeza, Turf Club, The Underground Railroad to Candyland, The Velvet Teen, Wild, XOXO Panda, Yael Torbati, Zapruder's